YOSEMITE
an enduring treasure

BY KEITH S. WALKLET

YOSEMITE
ASSOCIATION

Yosemite National Park,
California

YOSEMITE ASSOCIATION

Text ©2001
by the Yosemite Association

All Photographs ©2001 Keith S. Walklet
*(except author photo; page 19, Half Dome
in Misty Sunset; page 38, Pine Tree in
Jointed Granite; and page 41, Misty Meadow,
©2001 by Annette Bottaro-Walklet)*

Historic photographs courtesy
Yosemite Research Library.

Design by Melanie Doherty Design,
San Francisco.

Printed in Singapore.

○ **INSIDE FRONT COVER**
Pine trees burned in the sum-
mer fires of 1990 cast shadows
across a hillside thick with
lupine. A member of the
pea family, lupine was once
thought to rob the soil of
nutrients, though it is now
recognized as a nitrogen fixer.
It is usually among the first
plants to appear following
a forest fire.

○ **FRONT COVER** Upper Yose-
mite Fall leaps 1,430 feet in a
graceful arc from the northern
wall of Yosemite Valley to join
the swollen waters of the
Merced River. Warm spring-
time temperatures trigger
snow melt that feeds the falls,
and signal trees to produce
brilliant new leaves.

dedication

To my parents Peggy and John J.
Walklet, Jr., who lovingly encour-
aged my exploration of the natural
world while enduring numerous
undomesticated and undocumented
contributions to our family's house-
hold in the name of science and
understanding.

acknowledgements

I thank the Taylor family, who pro-
vided the impetus for my working
in Yellowstone in 1981, an exper-
ience that gave me the courage to
launch my ongoing westward
journey of discovery.

For their passion and enthusiasm,
I am grateful to the Yosemite inter-
pretive community including
Yosemite Institute's Jim Paruk and
Pete Devine, Yosemite Association's
Penny Otwell and Lee Stetson,
the National Park Service's Ginger
Burley, Jim Corless, Dick Ewart,
Shelton Johnson, Martha Lee,
Cherry Payne, Valerie Pillsbury, Bob
Roney, Jeff Samco, and Rick Smith.

For patiently feeding my curiosity,
I am indebted to Linda Eade, Jim
Snyder, and Mary Vocelka of the
Yosemite Research Library, and
Barbara Beroza, Norma Craig,
Michael Dixon, and Dave Forgang
of the Yosemite Museum; for paving
the way with their well-researched
publications, I thank historians
Hank Johnston and Shirley Sargent.

For vision and perspective, I rec-
ognize my kindred spirits in the
Yosemite photographic community,
Fred Benz, Charles Cramer, Glenn
Crosby, Michael Frye, Jeff Grandy,
William Neill, Jeff Nicholas,
and Mike Osborne, who selflessly
shared their knowledge and
inspired my own creativity.

For opportunity, I thank John
Poimiroo for opening the door to
my interpretive career and sending
me to the archives; Steve Medley
and the Yosemite Association for the
honor of adding this title to their
list of outstanding publications; and
Tina Besa and everyone at Melanie
Doherty Design for skillfully and
beautifully presenting my thoughts
and images.

And most of all, I am thankful
for my soul-mate, Annette Bottaro-
Walklet, the greatest of all my
discoveries in Yosemite.

KEITH S. WALKLET

introduction

When visitors first began traveling to Yosemite in the 1850s, the grueling trip was only for the adventurous. The lengthy stay that typically followed was as much for recovery from the arduous journey as it was to admire this incredible assembly of geologic wonders, awe-inspiring waterfalls, and inconceivably immense sequoias. For those who could afford the week-long trip, the passage consisted of an exhausting ride in a jolting carriage or on horseback through the heat of the California's Central Valley, followed by a steep climb into the core of the Sierra on sometimes vague trails hewn from the wilderness.

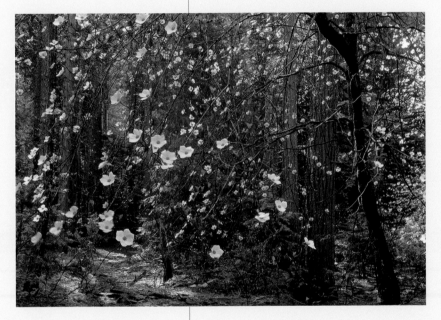

Members of some religious sects whip themselves to gain enlightenment, and other groups embark on lengthy pilgrimages for similar reasons. Given the difficulty of the trip to Yosemite, it might be fair to include early park tourists in the "religious self-flagellation" category. Despite the discomfort, for an earthly glimpse of heaven in the guise of Yosemite, many happily made the trip.

With the advent of the automobile and improved highways, the formerly difficult trip was reduced from a multi-day epic to a single day's journey. As early as the 1920s, one park hotelier noted that the average length of a tourist's stay had shortened as well, from two weeks to just two days. The most recent figures show that the typical Yosemite day visitor spends just four hours taking in the sights.

○ Almost as notable as Yosemite's waterfalls in late April and early May are the Pacific dogwood blooms. The showy, pale bracts that are often confused with the tree's true flowers seem to defy gravity, waving gently on delicate branches among pines and cedars.

My introduction to Yosemite was a week-long visit. My second stopover lasted fourteen years. If there was one thing I learned in all that time in this grand classroom, it is that the park shrinks when viewed through the window of any vehicle. In contrast, time and space expand exponentially when one ventures into the park on foot. Maps of Yosemite National Park define a boundary that encompasses 1,170 square miles. To understand and appreciate such dimensions demands a lifetime of exploration, a task that could be a vocation in itself. Unfortunately, few can afford such a luxury. I came close. I worked in Yosemite and devoted my spare time to its exploration. My camera served to record what I encountered and distilled my experiences into meaningful form.

I have multiple purposes in developing this book. First, it should serve to remind visitors of their own experiences among the park's world-renowned features. Second, by providing a glimpse of the complex interrelationships between landforms and life forms, it should surprise and entice readers with hidden details and beauty they may have overlooked. Third, it should portray Yosemite in a way that tantalizes readers and gives them reason to eagerly anticipate their next visit. Finally, and most important for me, the book should foster an appreciation for the wisdom that prevailed when this land was set aside on June 30, 1864, to shine in all its glory for future generations.

The Merced River Canyon recedes toward California's San Joaquin Valley in a procession of silhouetted ridges. Distinctly V-shaped, the river-carved canyon contrasts with the U shape of Yosemite Valley whose walls were glacially modified.

I recall my first visit to Yosemite National Park in July of 1984, riding a motorcycle into Yosemite Valley on Route 140 out of the sweltering heat of the Central Valley. The route traces the meandering Merced River—a shallow stream in July with bathers comfortably dispersed along its banks. The incredibly steep slopes were dominated by dry brown grass waving gently in the canyon breeze. The water's gentle pace in the lazy days of summer belied the power that cut this magnificent canyon over thousands of years.

first impressions

I had a vague notion of where I was going—this 1,170-square-mile island of green shaped like an egg in the road atlas—having heard of the waterfalls and granite cliffs. I arrived, however, with few expectations. Because people were universally effusive about the place, my anticipation grew steadily.

I moved progressively deeper into the "wilderness," swept along in the steady current of park-bound traffic. The road clings to the side of the steep slopes, blasted out of ancient striped rock that was once alternating layers of plant and animal remains at the bottom of the Pacific Ocean.

The twists and turns of the pavement kept my attention focused on navigation and forced me to steal glances at the scenery.

Torn between the desire to stop and take a closer look at the beauty I was passing, and a more intense curiosity about what lay around the next curve, I pushed on.

I don't recall pausing once between Mariposa and Yosemite Valley, but I do remember my pulse jumped a notch when the metamorphic rock gave way to the first exposed granite slab at the park boundary in El Portal.

At this point, the road narrowed, the river's pace quickened as it tumbled over boulders, the air temperatures grew noticeably cooler, and the fragrances turned decidedly more alpine in character. When the road finally reached the flat valley floor, I sensed that something extraordinary was imminent; moments later my gaze fell upon the granite cliffs of Cathedral Rocks and towering El Capitan. I finally stopped, my face breaking into a grin that has yet to fade.

○ Arranged as if posed for a group portrait are the park's most famous icons: LEFT TO RIGHT El Capitan, Clouds Rest, Half Dome, Sentinel Rock, and Bridalveil Fall spilling from the smiling edge

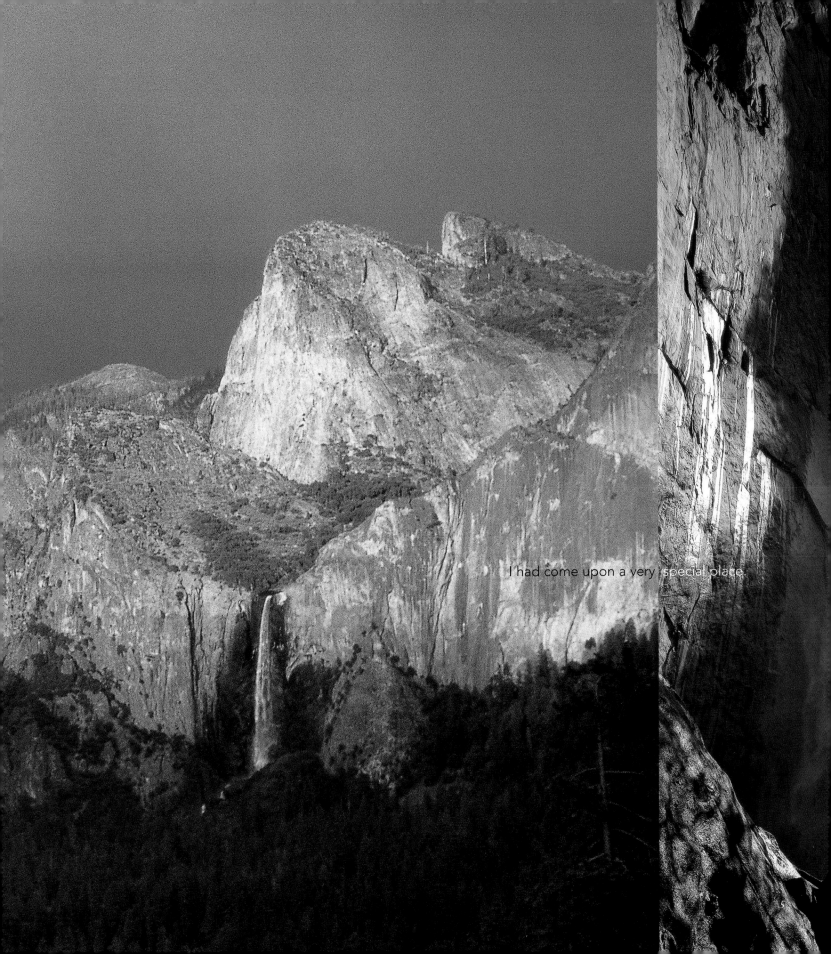

I had come upon a very special place.

○ The morning sun highlights curls of mist peeling away from the torrent of water plummeting over 1,430-foot Upper Yosemite Fall. A 3.6-mile trail, with an elevation gain of 2,700 feet, leads past this viewpoint, where rainbows are visible in the mist in late afternoon.

○ RIGHT Plunging water explodes as it collides with the granite apron of 594-foot-high Nevada Fall. The billowing clouds of whitewater were the inspiration for the fall's name, a Spanish word that translates to "snowy."

a closer look

Situated in the Sierra Nevada
mountain range of central California
roughly 200 miles east of San Fran-
cisco, Yosemite National Park is
home to some of the world's most
spectacular scenery, including two-
thousand-year-old giant sequoias,
immense granite cliffs, and an
unparalleled collection of thun-
dering waterfalls. So wondrous
are its features, this was the first
tract of land ever set aside by
Congress solely "for public use,
resort, and recreation for all time."

Ranging in elevation from 2,000 feet to over 13,000 feet, the park embraces 5 distinct life zones, and

shelters 80 species of mammals, 247 species of birds, 40 species of reptiles,

o FAR LEFT A visitor explores a cavity in the base of a giant sequoia. An ancient fire scar, the cavity is testament to the tree's tenacity for life. Park managers use controlled burns to clear underbrush in sequoia groves and to ensure proper conditions for seed germination.

o MIDDLE Ice traces abstract patterns around rocks in the Merced River. The terraces form when an initial freeze is followed by a series of reductions in the water flow, with new ice forming at each lower water level.

o Tens of ladybugs wedge themselves into the dried flower of a cow parsnip to insulate their bodies against the frigid winter temperatures. Vast congregations of the insects spend their winters along streams in Yosemite Valley.

37 species of native trees, and hundreds of species of native wildflowers and plants.

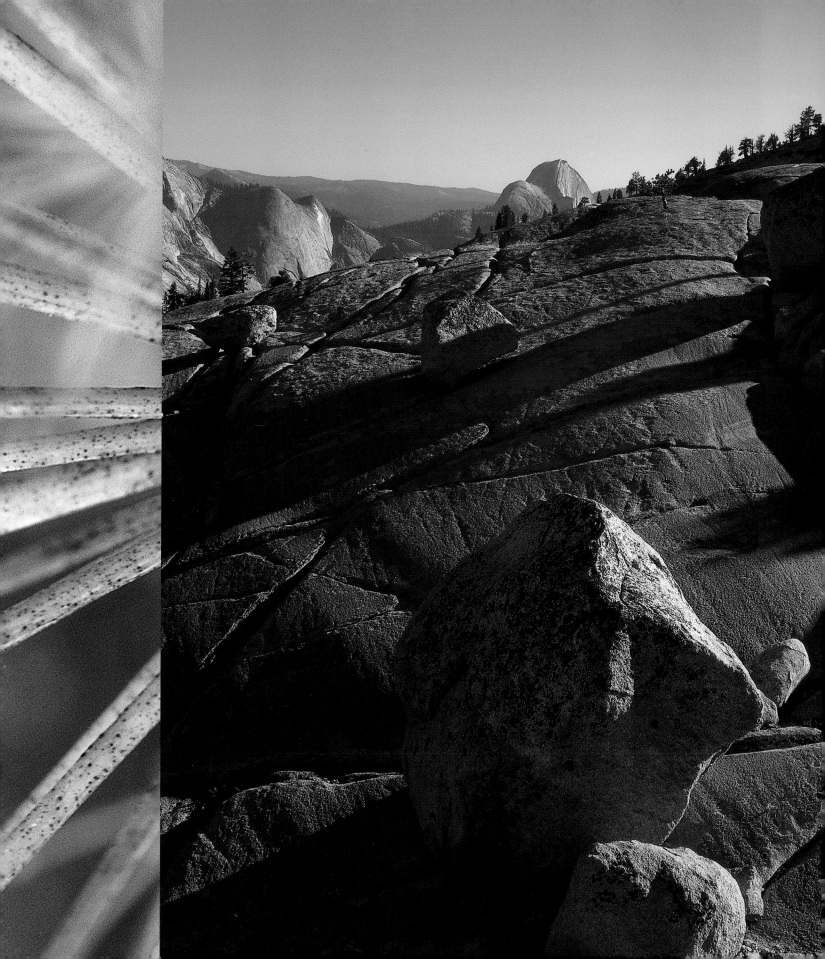

geology

Scientists believe this magnificent landscape once consisted of gentle rolling hills that were crisscrossed with a maze of stream systems. Underlying the hills was granite, forged by the intense heat and pressure beneath the earth's crust. Over approximately five million years, pressure along fault lines of the eastern slope of the Sierra Nevada caused the granite to rise in a series of dramatic uplifts, tilting it to the west. The streams, including the Merced River, ran faster as the incline increased, and the energy of the moving water and fine particles of disintegrating rock carved deeply-incised, V-shaped river canyons.

Geologists believe that following this erosion of the canyons at least three periods of major glacial intrusion and recession occurred. During these times, colder temperatures prevailed and snowfall exceeded snow melt. Layer upon layer of snow accumulated until only the highest peaks of the Sierra Nevada protruded above the ocean of ice. The snow and ice compacted, spawning glaciers that polished and sculpted the landscape, exposing the granite domes and spires. Spilling out of the high country, the glaciers transformed the lower canyons into U-shaped valleys, of which Yosemite Valley is the most well-known. Interestingly, this transformation had more to do with the weakness of the rock than the strength of the ice. The glaciers merely took advantage of the highly-fractured granite that lined the river canyons.

The ice of the Yosemite Glacier (the last in Yosemite Valley) finally melted away 10,000 years ago. When it did, a pile of rock debris that had accumulated at its western terminus acted as a natural dam and helped form 2,000-foot-deep Lake Yosemite. Tributary creeks that had once joined the main stream at the same elevation, now plunged off 2,000-foot-high cliffs, creating the park's famed waterfalls. The present valley floor was formed later as sediment washed down out of the high country and filled in Lake Yosemite.

○ LEFT Half Dome peeks over the ridge at Olmsted Point, named for former Yosemite Commissioner Fredrick Law Olmsted, the landscape architect who designed New York City's Central Park. The jointed granite was sculpted by glaciers, which left random boulders called "erratics" when they receded.

○ RIGHT Vernal Fall (left) and Nevada Fall (right) make up the two major steps of the Giant Staircase, a striking remnant of glacial activity.

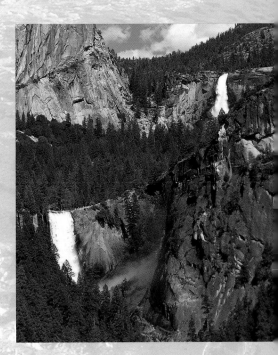

history

Yosemite's first human residents were Native Americans who moved to the region some 7,000 to 10,000 years ago.

Various tribes lived in the area over the years, the most recent of which was a Miwok tribe that called Yosemite Valley "Ahwahnee," a word believed to mean "place of the gaping mouth" and possibly a description of the valley. They referred to themselves as the "Ahwahneechee."

A hunting and gathering society, the Ahwahneechee lived off the land, migrating from the foothills to Yosemite Valley and the high country beyond in the summer months. They harvested acorns and other plant materials, hunted, and fished. The discovery of gold in California ended this peaceable lifestyle.

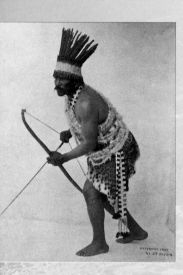

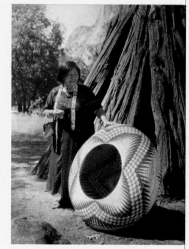

○ ABOVE, LEFT Francisco Georgely, a Miwok tribal leader, holds a reflex sinew-backed bow while posing in traditional attire including a flicker feather headband. The Yosemite Indians were skilled hunters, and made many different weapons and tools.

○ ABOVE, MIDDLE & RIGHT Miwok women are legendary for their intricately woven baskets. In 1934, Lucy Telles was photographed with the most famous basket of the Yosemite Museum collection, a piece that took her four years to complete.

○ TOP The oldest structure still standing in Yosemite Valley, the chapel was built in 1879 near the base of Sentinel Rock. It was later moved to its present location, the site of the old Yosemite Village.

○ BOTTOM The famed hotel known as The Ahwahnee was designed of rough-hewn granite and oversize timbers to help it blend with the park environment. Completed in 1927, the hotel and its "rustic" style were the inspiration for similar structures at Death Valley, Grand Canyon, Bryce Canyon, and Zion National Parks.

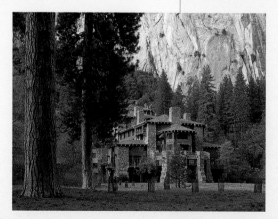

Some of the Yosemite Indians, angered by the encroachment of the western miners into their traditional territory, attacked a trading post in the Merced River Canyon. In retaliation, the miners organized the state-sanctioned Mariposa Battalion. While pursuing the Yosemite Indians on March 27, 1851, that group of soldiers became the first European Americans to enter and explore Yosemite Valley. The beauty of the valley captured the imagination of battalion member Lafayette Bunnell, who described the landscape with near reverence. "The grandeur of the scene was but softened by the haze that hung over the valley— light as gossamer—and by the clouds which partially dimmed the higher cliffs and mountains."

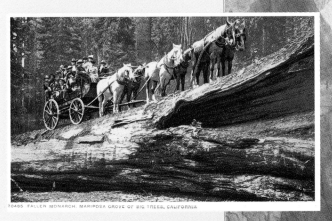

70465 FALLEN MONARCH, MARIPOSA GROVE OF BIG TREES, CALIFORNIA

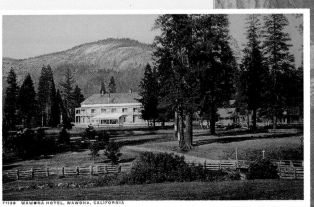

71138 WAWONA HOTEL, WAWONA, CALIFORNIA

o TOP Something to write home about! A turn-of-the-century postcard depicts a stage full of sightseers on the trunk of the Fallen Monarch in the Mariposa Grove of Big Trees.

o BOTTOM By the late 1800s, the Wawona Hotel, successor to Galen Clark's rustic guest cabin, was a self-sufficient resort with its own 100-acre garden, livestock, and New England-style covered bridge.

o The first published image of Yosemite was this illustration, *The Yo-Hamite Falls*, created in 1855 by artist Thomas Ayres, a member of the first tourist party to visit the valley. His view documented a landscape of soaring cliffs and waterfalls, open meadows studded with oaks, and relatively few conifers.

By 1855, the first party of tourists arrived to see the wonders of Yosemite for themselves, and soon after, entrepreneurs began to settle in Yosemite Valley. In the midst of the Civil War, a concerned group of influential Californians worried that the valley would be despoiled and ruined by commercialism, persuaded Abraham Lincoln to sign the Yosemite Grant. This precedent-setting act prevented additional unauthorized development of Yosemite Valley and the Mariposa Grove of Big Trees, and deeded them to the State of California as a protected public reserve. Technically, Yellowstone became the first national park in 1875, but the 1864 signing of the grant was clearly the first time in history that a government had set aside land for the benefit of the public.

1868

1879

1903

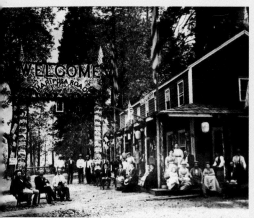

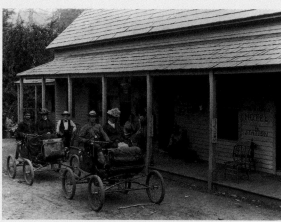

ABOVE, LEFT TO RIGHT

1875 Coulter and Murphy's Hotel was festooned with flags and banners for the opening of Mariposa Wagon Road on July 22, 1875. The route revolutionized travel to the park, which had formerly been restricted to those on horseback or foot.

1879 The three Rs were taught to children of park residents in this one-room schoolhouse located near Sentinel Bridge in Yosemite Valley.

1900 Two "horseless carriages" pictured at Priest's Hotel just after the turn of the century were among the earliest motor vehicles to make the journey to Yosemite.

1927 The explosion in park visitation that occurred following the completion of Route 140, "The All-Year Highway," resulted in unexpected overcrowding. These are overflow campers in Stoneman Meadow during Memorial Day weekend.

1934 Eleanor Roosevelt must have felt safe amidst this group of park rangers. Roosevelt Lake in Yosemite's high country was named to commemorate her 1934 visit to the park.

1894

Members of the 4th Cavalry left this blaze on a tree trunk in Spiller Canyon. Prior to the creation of the National Park Service in 1916, the U.S. Cavalry patrolled the park, creating many of the trails still used today.

In 1890, Congress passed a law that created a larger Yosemite National Park, including the high peaks and meadows that surrounded Yosemite Valley. This federal reserve was the product of efforts led by Robert Underwood Johnson, editor of *Century Magazine,* and conservationist John Muir, who believed that the land was being destroyed by grazing and timber interests.

1927

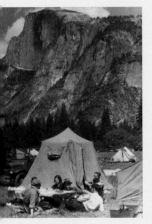

1934

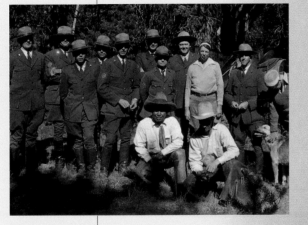

In 1906, management of Yosemite Valley and the Mariposa Grove was transferred from the State of California to the federal government, and in 1932, the Wawona Basin, including the Wawona Hotel and meadow were purchased and added to the national park. These additions, as well as subtractions from the eastern boundaries of the park, have resulted in the park's present size and shape.

1910

The dramatic Overhanging Rock at Glacier Point served as a 3,214-foot-high stage for automobiles, stuntmen, and politicians through the years.

○ Located south of Yosemite Valley, Mt. Starr King stands 9,902 feet above sea level. Its smooth granite surface contrasts with the ragged peaks of the imposing Clark Range behind it.

○ RIGHT 7,038-foot Sentinel Rock stands guard on the southern rim of Yosemite Valley. The native Ahwahnee-chee people knew the rock as "Loya," meaning "long water basket."

○ FAR RIGHT A pair of cables, 600 feet in length, assists hikers making the steep final ascent of Half Dome's rounded backside. The stren-uous, 17-mile roundtrip hike, one of the park's most popular, gains a full vertical mile of elevation.

cliffs, domes, and peaks
scenic treasures

"In Yosemite, the grandeur of these mountains is perhaps unmatched in the globe; for here they strip themselves like athletes for exhibition and stand perpendicular granite walls, showing their entire height and wearing a liberty cap on the head."

RALPH WALDO EMERSON

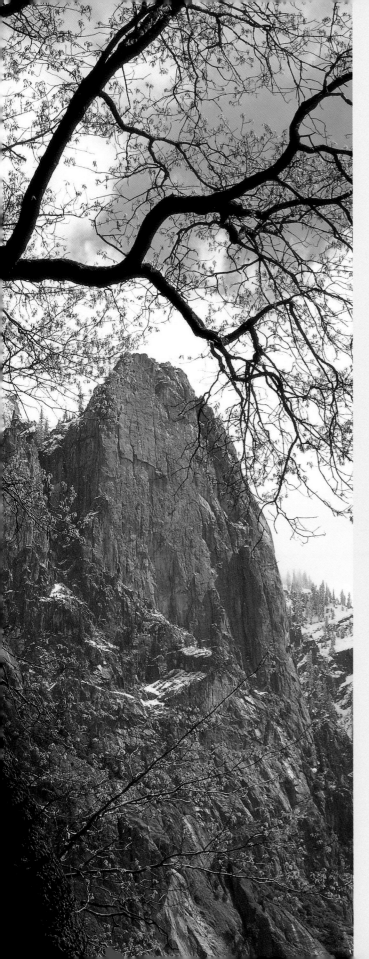

Yosemite's distinctive landscape is a product of granite and ice, with a dash of gravity, and lots of time to stew. It's a classic recipe, though one that was never so skillfully prepared as here.

Granite, the primary rock in the park, was formed under intense pressure beneath the surface of the earth. As the rock overlying Yosemite's granite was eroded away, pressures on the underlying rock were relieved and "cracks" or "joints" formed in it. Where the joints occur, rock peels off like layers of an onion, in a process called exfoliation.

Glaciers sculpted the fractured rock, combining tremendous weight and freezing temperatures to chip away at seemingly impregnable geologic forms. Most of the granite domes in the Yosemite region started out as much larger formations, but as multiple layers flaked off them, they eventually assumed the familiar dome-like shapes that are characteristic of this area.

The shape of half dome, Yosemite's most famous landmark, is the result of both horizontal and vertical jointing. Imagine Half Dome as a molten bubble floating slowly to the surface through more dense molten rock. As it neared the surface, its upward movement was limited by a roof of overlying rock.

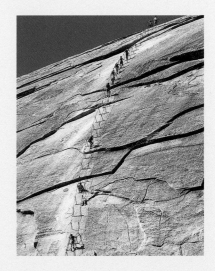

When the overlying rock was removed by erosion, the hardened bubble was exposed and relieved of pressure, and the outer layers of granite began to spall off. What remains today is the round-shaped core of the bubble.

The sheer face of Half Dome was created when vertical weaknesses in the rock were exploited by glaciers traveling down Yosemite Valley. Water trapped in the vertical joints on the north side of Half Dome froze, expanded, and gradually enlarged the fractures. With the constant pull of gravity, the rock ultimately broke loose, fell onto the glacier below, and was carried farther to the west and re-deposited.

This process was repeated throughout Yosemite to form the bold landscape highlighted by towering cliffs and unique domes.

HALF DOME

Half Dome (8,842 feet) is the most-recognized feature in Yosemite, its western face a sheer cliff of granite.

o Three views of the park's most famous landmark reveal that its name is misleading. Three-quarter Dome or 80% Dome would be more accurate, as most scientists believe that little of the rock's original structure is missing. From Yosemite Valley *(view at far right)*, Half Dome appears to have been cleaved in two, yet from Washburn Point *(view top left)*, and the summit of Mt. Hoffmann *(bottom right)*, the peak's elliptical shape is more apparent.

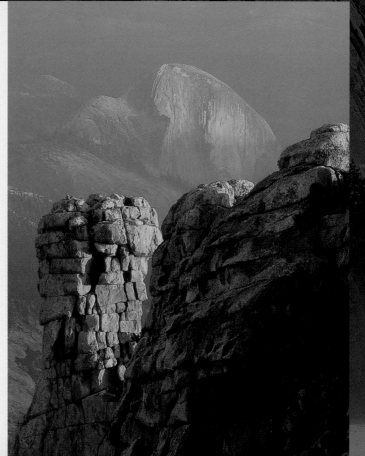

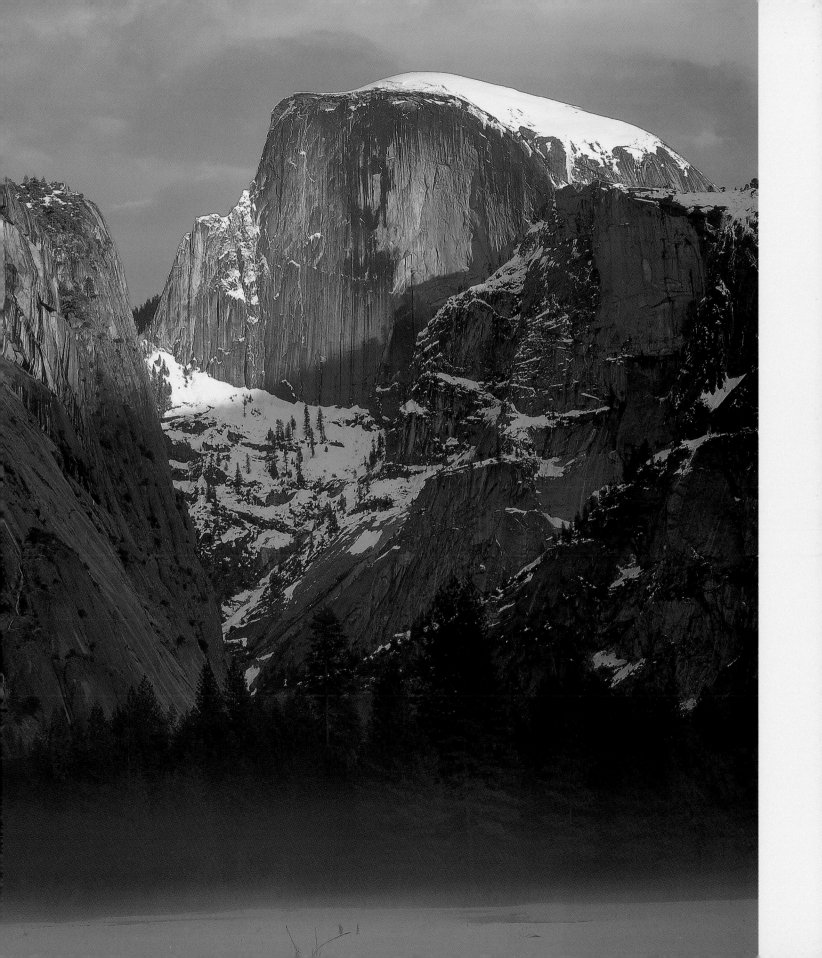

el capitan is second only to Half Dome as a recognizable Yosemite landmark. This unbroken block of granite—the largest in the world—stands guard over the western end of the valley, rising 3,593 feet from the valley floor. Its vertical face provides climbers with some of the most challenging "big wall" routes in the world.

Another prominent feature in Yosemite Valley is **sentinel rock** (7,038 feet), located on the south wall and named for its likeness to a watchtower. Actually a tall blade of rock, its appearance changes dramatically depending upon one's angle of view.

While no glaciers can be seen from **glacier point**, this promontory 3,214 feet above the valley floor provides an exceptional vantage point for observing the park's high country, the "Giant Staircase" of Vernal and Nevada Falls, sculpted canyons, and a multitude of peaks. The geographic center of the park, 10,180-foot **mt. hoffmann**, and the park's tallest peak, **mt. lyell** (13,114 feet), are also visible from the point.

○ TOP LEFT A solitary hiker gazes off the northwest face of Mt. Hoffmann, the geographic center of the park. The summit of Hoffmann is reached by way of a 3-mile-long trail with a 2,000-foot elevation gain, and affords excellent views in all directions.

○ MIDDLE LEFT Because its rock is highly resistant to weathering and nearly devoid of joints, El Capitan remains largely intact. It is one of the sheerest cliffs in the world.

○ BOTTOM LEFT Matthes Crest, a razor-sharp ridge of rock, was named for geologist Francois E. Matthes. It stretches toward the rugged peaks of the Clark Range to the south.

○ RIGHT Visitors stroll through the giant sequoias of the Upper Mariposa Grove. Yosemite is home to three groves of these giants, totaling nearly 700 trees, including one that is over 40 feet in diameter.

○ FAR RIGHT Sequoia cones, about the size of a chicken egg, will eventually dry out and release seeds resembling flakes of oatmeal. Mature trees can live to be 3,000 years of age, and sequoias are considered the largest organisms on the planet by volume.

the giant sequoias

There is a stillness about the groves of *Sequoiadendron giganteum*, a cathedral-like quality that inspires reverence at all times of the year. It is a silence full of purpose, as if the trees are so immersed in the business of growing that we dare not interrupt them.

When the Yosemite Grant was enacted in 1864, Congress explicitly set aside the sequoias in the mariposa grove to keep them from being logged for grapestakes—a fate that befell sequoias in the nearby Nelder Grove.

Given protection from the lumberman's ax, the trees became symbols of fulfilled potential, growing from an oatmeal-flake-sized seed to mature tree—the comparative size of the same proportion that a mature sequoia bears to planet Earth.

Yosemite has three groves of sequoias, the largest being the Mariposa Grove with over 600 trees, some with trunks 40 feet in diameter and limbs the size of mature pine trees. Within the Mariposa Grove stands the grizzly giant, the most senior sequoia on record, already some 700 years old when Christ was born. The grove is also the site of one of the most well-known dead trees, the wawona tunnel tree.

Supine since it collapsed in 1969, the Tunnel Tree is probably the most famous tree of all time. Its death was undoubtedly hastened when the burn scar in its base was enlarged to permit carriages to pass through its trunk.

The two other groves, the tuolumne grove and merced grove, feature much smaller clusters of the cinnamon-colored behemoths. Containing 29 and 20 trees respectively, the groves are reached by walking on trails that formerly served as toll roads. By virtue of being less frequented, these two groves seem more wild than the popular Mariposa Grove. Here the silence is broken only by the pointed scolding of chickarees, who take a few moments between acrobatic stunts and cone-cutting to provide choice words to whomever should wander by.

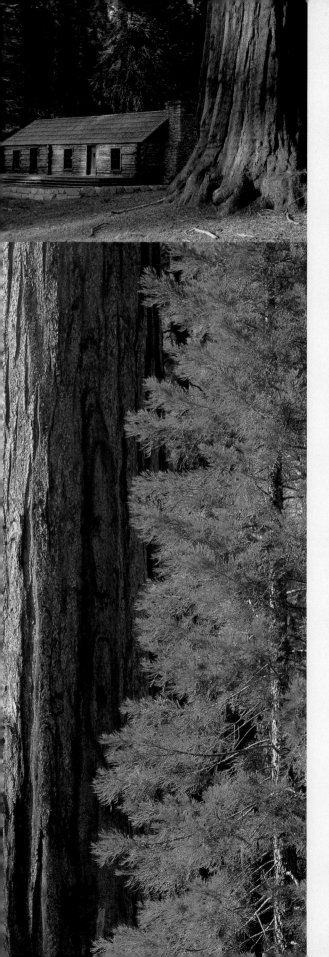

the seasons

Selecting a favorite season in Yosemite is akin to choosing a favorite flower from a field of blossoms at the peak of perfection; each of the park's seasons presents its own superlative experience. **winter** offers the soft embrace of silence, the magic of snowstorms, skiing, and ice-skating. **spring** brings the trill of the red-winged black bird, dogwood blossoms like a thousand white butterflies suspended between fragile tree limbs, and the deafening roar of waterfalls. **summer** provides afternoon thunderstorms and access to the alpine landscape of Yosemite's high country, while **autumn** features the festive hues of aspen, big leaf maple, and black oaks.

o TOP LEFT A sequoia dwarfs a replica of Galen Clark's cabin in the Upper Mariposa Grove. Clark was named the first guardian of Yosemite Valley and the Mariposa Grove when they came under the protection of the state of California in 1864.

o BOTTOM LEFT The cinnamon-colored bark of a mature giant sequoia contrasts with the feathery green foliage of a younger specimen. Yosemite's Native Americans called the massive trees "wawona," after the hoot of an owl.

o RIGHT Snow carpets a grove of cottonwoods along the Merced River in Yosemite Valley. Situated at an elevation of 4,000 feet, the valley has a surprisingly mild climate, though snow accumulations of three feet or more are possible.

o FAR RIGHT Wind-driven snow coats a black oak framing the oversize window of The Ahwahnee.

Muir had a fascination with the dynamic qualities of storms, embracing the power of what he reminded us were creative forces. He would undoubtedly have preferred to be enveloped in the crisp silence of the outdoors, but there is also much to be said for considering the storm from the warm confines of the Great Lounge of The Ahwahnee. With the benefit of floor-to-ceiling windows, visitors can trace each flake's gentle descent from high in the sky to its earthly resting place.

winter storms

There is nothing quite so magical as a winter weather in Yosemite. In particular, the edges of storms are mesmerizing blends of strength and grace that have inspired iconic imagery from artists and writers alike. One need do little more than watch tiny, wind-driven snowflakes to understand the energy in a stunning photograph of a clearing storm by Ansel Adams, or the passion in John Muir's words, "Glorious are these rocks and waters arrayed in storm robes."

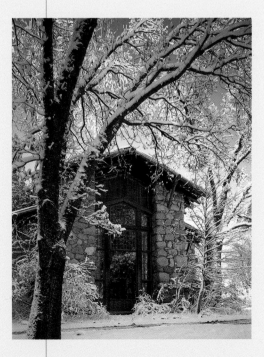

Individuals fortunate enough to be in the park for one of these "winterludes" can often be found wandering, or should I say wondering about, staring at their "new" park, with good reason.

Every branch of every tree, every crack and nubbin on the cliffs is blessed.

When the curtain of clouds parts to reveal the new scene, a subtle transition from a state of "blizzard" to "blessed" can be observed, a timeless period that is one of life's most exquisite secrets, when every atom is clearly in balance, as if Mother Nature were holding her breath, pausing to admire her handiwork.

When the sun's rays finally begin to warm the snow-laden trees, immense amounts of energy are released, the balance is altered, and the trees begin shedding their crystalline burden in arboreal avalanches of frozen flour. The sunbeams scatter in this white smoke, as do those who, so distracted by the beauty, neglect to pay heed to where they are walking.

o TOP Moisture released from melting snow during the warmth of the day freezes at night, coating plants with hoarfrost. Ice crystals over an inch in length can form on the south side of the valley.

o MIDDLE Snow clings to the cliffs and trees along the Merced River as a storm clears on a brisk winter morning. In minutes, the warmth of the sun's rays can melt the white covering except in the deepest shadows.

o BOTTOM The elm in Cook's Meadow strains under the weight of a foot of new snow. Conifers are better adapted to their winter environment with limber branches and slippery foliage that sheds snow easily.

Indeed, observing where one walks following a snowfall is a quick litmus test for determining who is a local and who is not. Visitors, mouth agape, are prone to stumbling into these chilly booby traps, while locals travel "between" the trees instead of beneath them, stepping back and forth, weaving in and out, in a delightful dance with their mischievous partners.

The accompaniment to this dance is a veritable symphony of sounds that gradually become noticeable as the activity level increases. At first, the steady rhythm of footsteps or skis in the snow keeps time. Laughter and the chatter of the park wildlife—feathered, furry and human alike—is sprinkled in for a melody. High notes of dripping water build to a crescendo, punctuated by the deep roar of ice breaking loose from the cliffs and crashing on the rock, hundreds, and sometimes thousands of feet below.

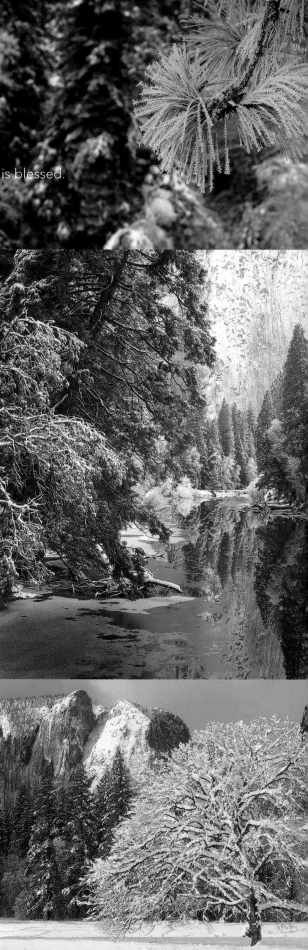

EL CAPITAN

El Capitan (7,569 feet) towers 3,593 feet over the valley floor and is one of the best places to observe climbers in the park.

o The striking profile of El Capitan is reflected in the Merced River as the afternoon light illuminates its face.

spring waterfalls

○ RIGHT Light spilling through a
break in the brooding clouds
of an afternoon thunderstorm
finds Bridalveil Fall surging
with spring runoff. By late sum-
mer, the 620-foot fall will have
diminished to a gossamer
curtain of wind-blown water.

○ FAR RIGHT, TOP Winter
storms regularly bring rain,
followed by snow. Waterfalls
like Vernal, reduced to a
trickle in winter, swell with the
additional moisture and often
are left framed in white when
the weather clears.

○ FAR RIGHT, BOTTOM A branch
of Royal Arch Cascade fans
out across the granite slabs on
the north side of Yosemite
Valley. Sliding 1,250 feet down
the rock incline, the cascade is
a narrow series of parallel
streams, but during heavy rain-
fall can spread to a width of
over 500 feet.

Come spring, warmer weather
triggers the snow melt. The
fountains of Yosemite, frozen
columns of ice in the winter,
explode with newfound exuber-
ance, leaping from the lofty
precipices on all sides of Yosemite
Valley in a variety of sizes and
shapes, thundering tall, wide,
and wispy, in one of the greatest
concentrations of spectacular
cascades in the world.

There are seven primary
waterfalls in Yosemite Valley that
run year-round, another five
ephemerals that dry up by
summer, and countless falls that
appear during major storms.

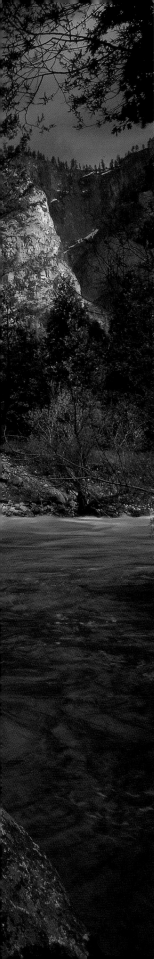

Perhaps it is because the cycle of life is so visible through the park's weather, that it is so easy to appreciate a good storm. The connection between winter snows and spring waterfalls is the most obvious example of the relationship. Throughout the winter, the Sierra's steep flank forces the Pacific storm clouds upward, capturing the moisture-laden air in the form of snow, like regular deposits to a waterfall bank account.

As the days grow longer and warmer, the mountains release this stored energy with enthusiasm, spending their savings in a binge that typically lasts little more than three months, exhausting snow-fields that took five months to accumulate in less than half that time. Still, no two years are exactly the same.

The depth and water content of the winter snows combined with the ambient temperature, determine the length and volume of the peak flow of the waterfalls. Many, like Yosemite Falls, are dependent on streams with little moisture-holding soil or lakes. Fed only with snow melt and rain, the falls are often dry by July or August.

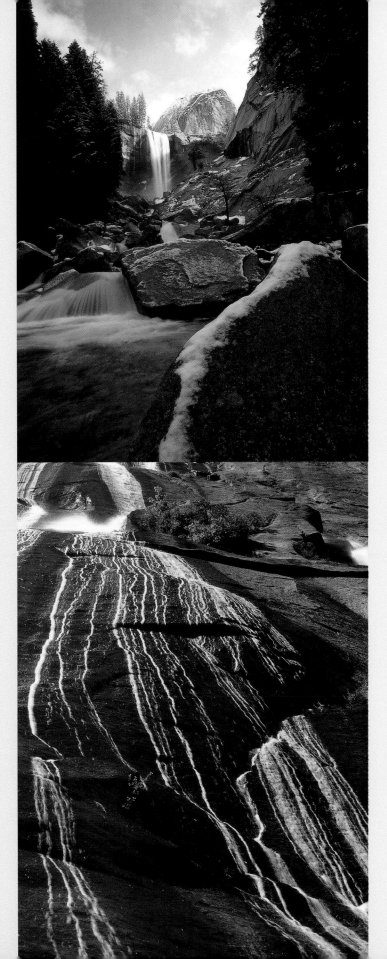

YOSEMITE FALLS

Yosemite Falls drop 2,425 feet in three sections (upper, 1,430 feet; middle, 675 feet; lower, 320 feet) making it the tallest waterfall in North America and fifth highest in the world.

Visitors can not truly claim to have experienced Yosemite until they have been baptized by the falls in spring. Horace Greeley, the famous newspaper editor, made his first visit to Yosemite in the late summer only to find Yosemite Falls dry. Outraged, he declared the dribble a "humbug." His disappointment is understandable, especially when one has had the experience of standing on the bridge below the same falls in May, the earth shaking, hair whipping in the incessant wind (the result of the water displacing air), and the roar of the falls obscuring all other sounds. "Humbug" hardly comes to mind!

At a combined 2,425 feet, the three cascades of yosemite falls qualify as the tallest series of falls in North America and fifth tallest in the world. A short trail to the bridge at the base of the 320-foot Lower Fall is a ten-minute walk that rewards hikers with a complete sensory experience. The truly fortunate will catch a glimpse of a lunar rainbow on moonlit nights. For more adventurous hikers, a 3.6-mile trail with an elevation gain of 2,700 feet takes one to the brink of the 1,430-foot Upper Fall, with outstanding views of the valley along the way.

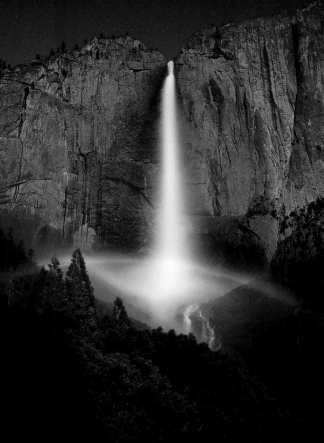

On the west side of El Capitan, less well-known ribbon fall, a 1,612-foot single drop, commands the honor of tallest single fall in North America and second tallest in the world behind Angel Fall in Venezuela.

Opposite Ribbon Fall is bridalveil fall, known to the Ahwahneechee of Yosemite Valley as "Pohono," which translates to "fall of the puffing wind." Strong winds generated by the convergence of the canyon walls where Bridalveil spills over the edge of its textbook-example "hanging valley," cause the water to sway from side to side. In late summer, the winds often blow the water back upward, momentarily suspending the gauzy spray in mid-air.

○ LEFT The specter of a rainbow floats in the mist of Yosemite Falls on a moonlit night. Lunar rainbows or "moonbows" were described by John Muir as "one of the most impressive and most cheering of all the blessed mountain evangels."

○ BELOW The water of Yosemite Creek follows a major joint system above Yosemite Valley before its half-mile vertical plunge to join the Merced River.

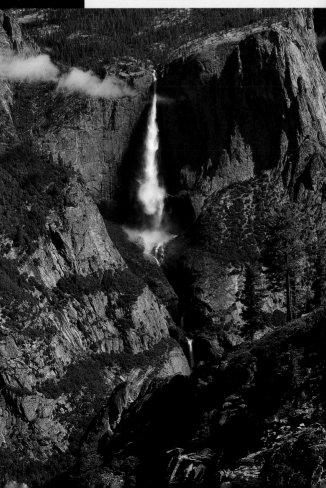

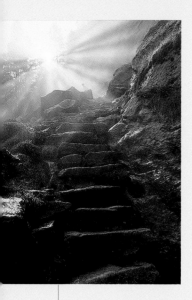

The most popular hike in Yosemite is undoubtedly up the Mist Trail to vernal fall (308 feet) and nevada fall, which at 594 feet is nearly twice as tall. Here, the journey is half the fun. At peak run-off, Vernal Fall plunges in a curtain of white nearly as wide as it is tall, landing on massive boulders at its base that dash the water into a fine mist for which the trail is named. Hikers on the trail get a refreshing respite while making the strenuous climb up the 700 or so granite steps to the railing over-looking the brink of Vernal, passing beneath countless rainbow arches hovering in the mist along the way. Vernal and Nevada make up the two major steps of the Giant Stair-case, an obvious remnant of the glacial activity.

○ ABOVE Sunlight bursts through the damp air on the Mist Trail. Water dashed against the rocks at the base of Vernal Fall create the clouds of moisture that give the trail its name.

○ RIGHT The last light of day glances off the water bursting from the narrow channel at the top of Nevada Fall. The fall is composed of countless white water comets that hurl them-selves rhythmically over the brink.

Plunging over the upper step of the Giant Staircase, the frothy waters of 594-foot-high Nevada Fall were described by John Muir as "the whitest of all the falls of the Valley."

NEVADA FALL

While the valley offers the greatest concentration of falls, there are many other cascades in Yosemite, any one of which would be a beautiful centerpiece to any park. Hetch Hetchy Reservoir, a near duplicate of Yosemite Valley that has been converted to a reservoir, features two impressive falls. tueeulala fall, at 1,000-feet, resembles Upper Yosemite Fall, and wapama is a 1,700-foot fall whose torrent of water is mostly hidden from view by the cliffs around it.

white cascade, tuolumne falls, california falls, and waterwheel falls descend in a less dramatic fashion than those that leap off thousand-foot cliffs, though this energetic string of waterfalls on the Tuolumne River is equally delightful. One could classify them as an entirely different species, a collection of frothy cascades, water comets, and spectacular rooster tails of spray called waterwheels that leapfrog and somersault over top of each other in their eager journey from the park's highest reaches down to Hetch Hetchy Reservoir.

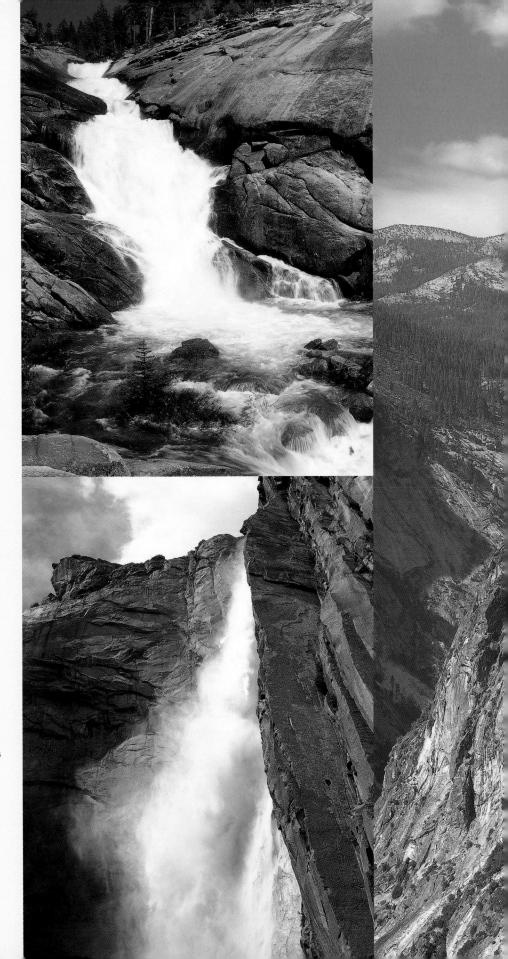

o TOP Overshadowed by the more famous and accessible falls of Yosemite Valley, Chilnualna Fall would receive top billing anywhere else. Its waters boil down a granite gully in a series of cascades culminating in a final leap of 50 feet.

o BOTTOM Just west of El Capitan, Ribbon Fall descends 1,612 feet between sheets of vertical granite to earn the honor as the highest continuous fall in North America. Drawing from a watershed of less than four square miles, the fall is often dry by early summer.

○ LEFT Mt. Hoffmann provides the backdrop as Illilouette Fall plummets 370 feet into a boulder-strewn side canyon of the Merced River.

○ RIGHT Perched atop Sentinel Dome, this gnarled Jeffrey pine, its branches bare, defies wind and weather despite having fallen victim to age, drought, and souvenir seekers

summer in
the high country

Yosemite Valley, only seven square miles of cliffs and waterfalls, is so compelling that few seem to realize that it represents but a mere 6% of the park. Yet, for some 90% of the more than four million annual visitors, the valley is the sole destination. To those who have discovered the beauty of the high country, that is just fine.

Between the western boundary of the park and its eastern limits, one encounters five different life zones while ascending nearly two vertical miles from 2,000 feet in elevation to 13,000 feet on the summit of Mt. Lyell. Such a broad range provides tremendous diversity of flora and fauna. The higher one progresses in elevation, the more one encounters wildlife and plants typical of more northerly latitudes.

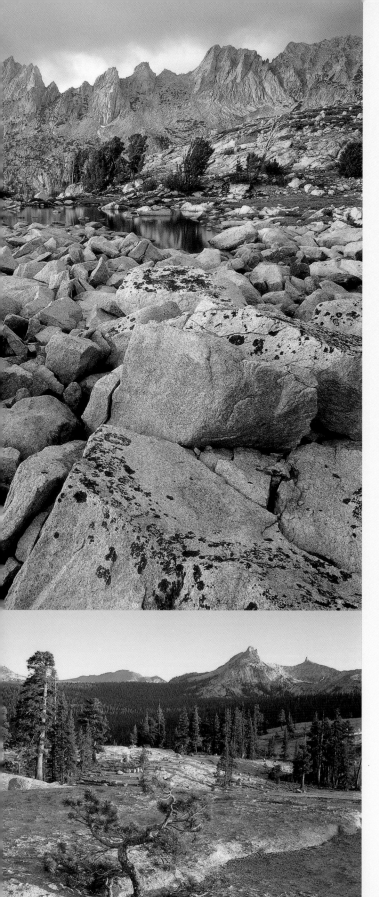

At the highest altitudes, the flowers and shrubs concentrate on surviving; twisted and gnarled, they cling to life where, if not for their existence, life would not seem possible. In such a barren landscape, a chance encounter with a cluster of cheerful magenta *Penstemon newberryi* tucked in a crevice, gives the appearance the blossoms are fed solely by the joy of living!

Accessible by automobile from roughly mid-June to early November, the high country is where locals recharge their batteries. Tuolumne Meadows, the largest subalpine meadow in the Sierra, is the hub of activity. It serves as an ideal base camp for comfortable day hikes and multi-day expeditions to explore miniature bonsai gardens of wildflowers, jewel-like lakes, and granite slabs.

At this elevation, evidence is everywhere that indicates the glaciers left only yesterday, an accurate time frame geologically. Erratics, boulders which fell onto the glacial ice and were transported as if on a conveyer belt until the ice melted, are perched in odd places, abandoned by the receding tide of ice. In many places the rock is as smooth as a dance floor, polished by the tremendous weight of the ice combined with Nature's brand of emery cloth, a fine grit called glacial flour. In other places, the glaciers clawed the rock, etching grooves in the polish. These striations were caused by larger rocks and sand embedded in the bottom of the glacier that scratched the rock as the ice slowly moves across it, one of the best indicators of which direction the glacier was moving.

Unlike Yosemite Valley, where all hikes seem to require a 3,000-foot elevation gain, Tuolumne's broad green expanse is situated at 8,600 feet, and hikers can wander for miles in all directions with little change in elevation.

Likewise, challenging hikes and technical climbs are readily accessible. This is "peak bagging" at its best, for in gaining a summit, it is often possible to reach two or three more by virtue of a short traverse.

○ TOP LEFT The setting sun casts deep shadows on the ragged crest of a glacial cirque filled with a jumble of lichen-covered erratics in Yosemite's high country.

○ BOTTOM LEFT A twisted pine above Tuolumne Meadows finds sufficient moisture and nutrients to grow in a granite joint. Because such joints act as natural gutters transporting water and minerals, plants congregate along these fracture lines.

○ ABOVE Lemmon's paintbrush (*Castilleja lemmonii*) adds a dash of magenta to the emerald green expanse of Tuolumne Meadows. Wildflowers carpet the meadows in successive waves of color throughout the summer.

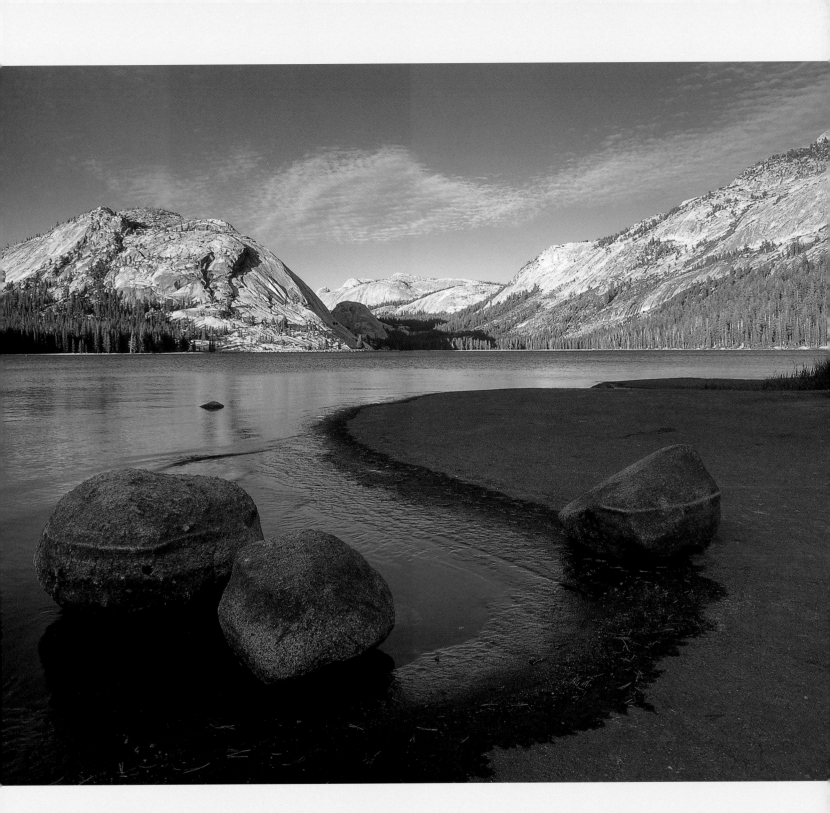

○ An assembly of bleached peaks
and bulbous domes lovingly
encircle Pywiack, "The Lake of
the Shining Rocks." Tenaya Lake,
as it is known today, was named
for the last chief of the Ahwah-
neechee Indian people.

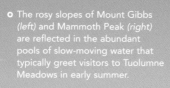

○ The rosy slopes of Mount Gibbs
(left) and Mammoth Peak *(right)*
are reflected in the abundant
pools of slow-moving water that
typically greet visitors to Tuolumne
Meadows in early summer.

TUOLUMNE MEADOWS

Situated at an elevation of 8,600 feet, Tuolumne Meadows extends roughly twelve miles from the flanks of Mt. Lyell to the brink of the Grand Canyon of the Tuolumne River.

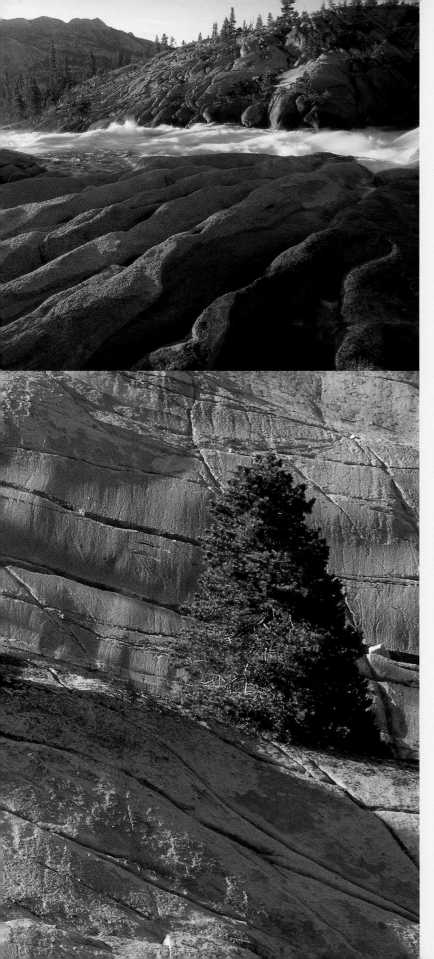

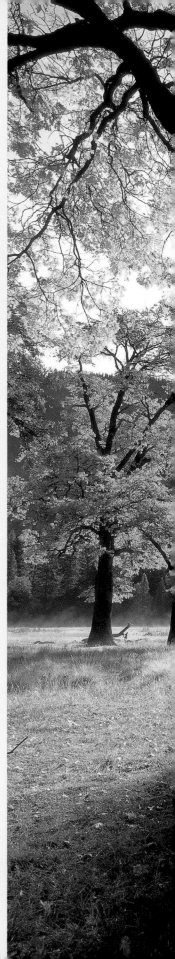

○ TOP Sunlight highlights the edges of granite sheets adjacent to the Tuolumne River. Joints between the sheets allow the penetration of water, seeds, and dirt, the agents that break down otherwise durable rock.

○ BOTTOM The glacially-polished granite near Olmsted Point has resisted weathering. Striations, grooves scratched in the smooth surface by ice-imbedded rocks, indicate the direction the glaciers flowed.

○ RIGHT Green chlorophyll masks the true color of leaves in spring and summer. When a plant's production of chlorophyll ends as it prepares for winter, the previously hidden leaf pigments—such as the yellow of this black oak—are revealed.

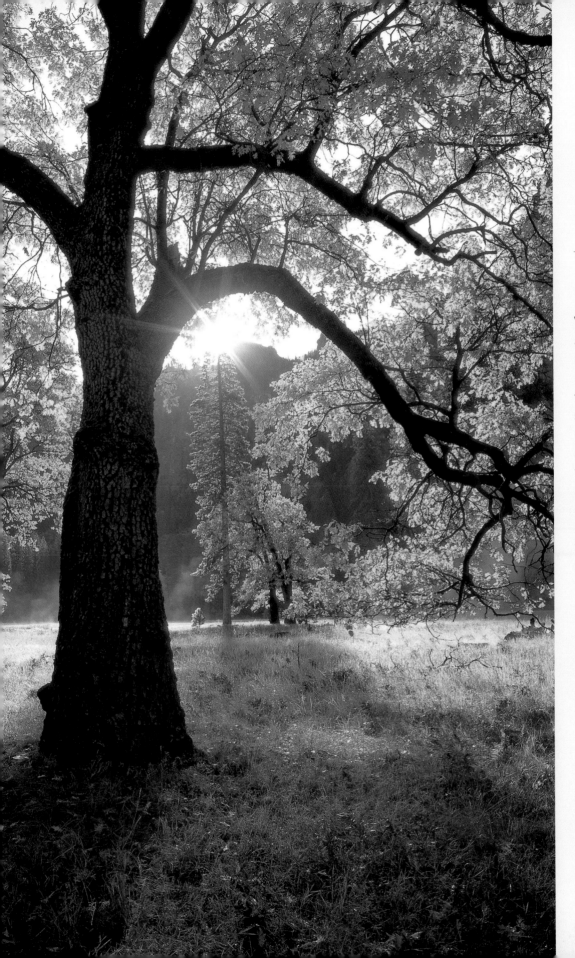

autumn color

Visitors to Yosemite in autumn are usually unprepared for the multitude of hues—from the brilliant gold of the cottonwoods to the broad, wine-red and salmon leaves of the Pacific dogwoods. It is surprising to find such a bright palate of color so far removed from the northeastern states, but Yosemite puts on a show worthy in its own right. Backlit by the morning sun, the foliage resembles stained glass set against the smoky blue hues of shadowy granite.

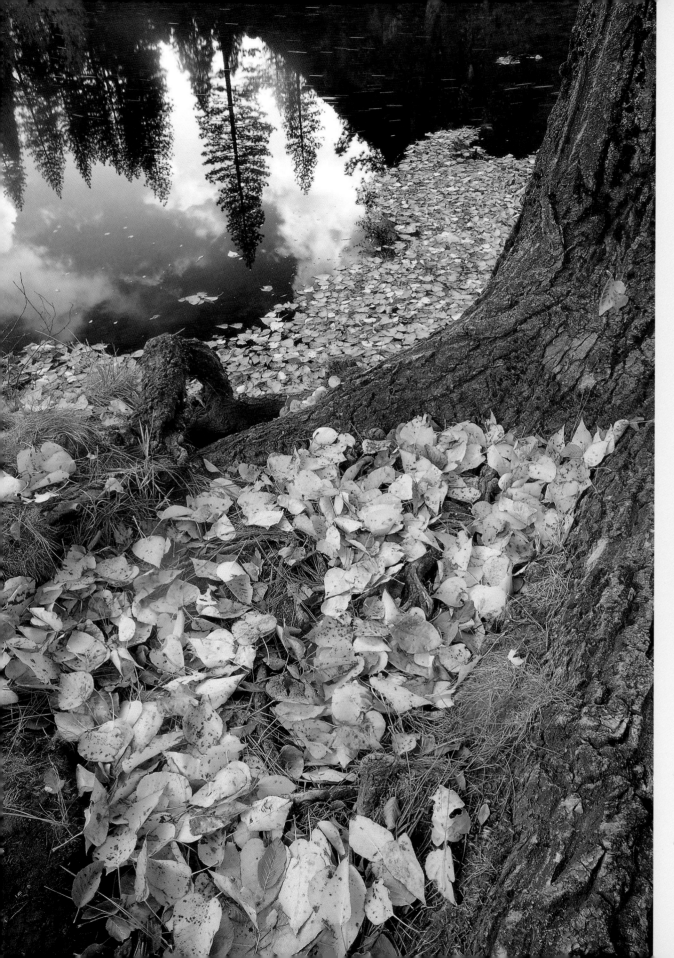

○ LEFT Cottonwoods, which thrive where fast-moving, oxygen-rich water routinely floods their roots, line the banks of the Merced River. Their brilliant gold leaves are among the most colorful each autumn in the park.

○ RIGHT, ABOVE The talus slopes on the southern side of Yosemite Valley, the realm of the big leaf maple, typically enjoy warm, sunny days and cool nights in autumn. These are ideal conditions for producing the eye-catching change of color in maple leaves.

○ RIGHT, BELOW Dogwood, willow, and azalea combine with the reddish tones of incense cedar bark to create a colorful autumn palate along the banks of the Merced River.

○ FAR RIGHT, ABOVE Clouds of mist drift upward as the morning sun warms meadow grasses following a day of rain and light snow.

○ FAR RIGHT, BELOW The leaves of black oaks (*Quercus kelloggii*) resolutely cling to their branches well into winter. Native Americans harvested the acorns from Yosemite's oaks for making a nutritious mush.

Autumn begins in late August when the bilberry carpets of the high country meadows turn scarlet, and the green aspen leaves take on the look of shimmering, golden coins. As the weeks pass, the change of season progresses downward, painting the willows surrounding Siesta Lake and the dogwoods among the sequoias of the Tuolumne and Merced Groves. Finally, fall arrives in Yosemite Valley and Wawona. There it is the Indian hemp whose change first proclaims the end of summer. In the valley, the elm in Cook's Meadow goes blonde, and big leaf maples scattered in the talus are painted various shades of yellow, seemingly overnight.

Last to give up their summer greens are the black oaks, whose leaves often cling to the branches through the winter, deep browns in a jeweled frame of frost. The peak of color in the valley typically occurs the last two weeks of October and the first two weeks of November, and then with barren branches, the trees await their winter robes.

The shorter autumn days are often warm and inviting, while evening temperatures drop, and clouds of mist float over the meadows and among the trees. Mule deer lock antlers to compete for the attention of female mates, and bears forage on an abundance of acorns. With school children returned to their classrooms, park visitation dwindles like the waterfalls.

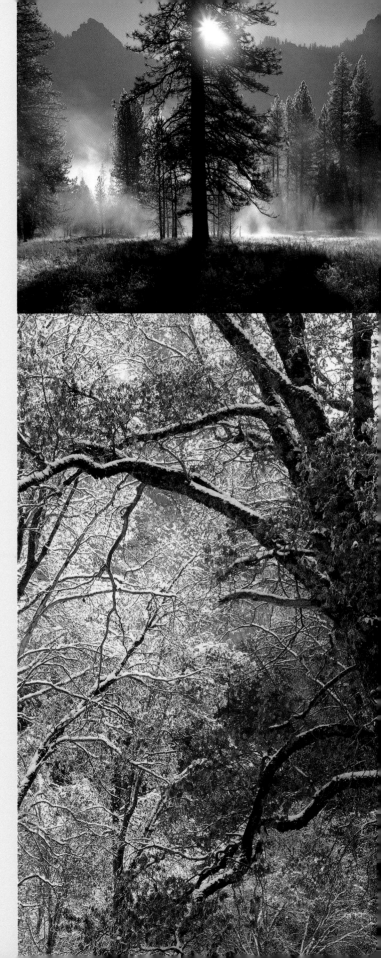

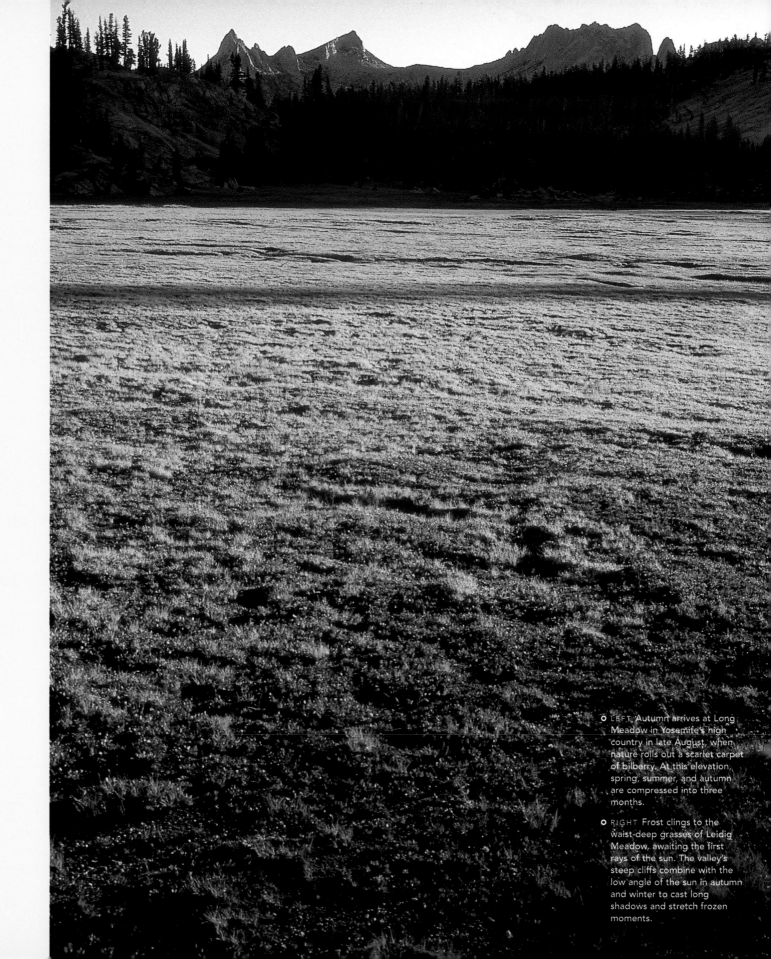

○ LEFT Autumn arrives at Long Meadow in Yosemite's high country in late August, when nature rolls out a scarlet carpet of bilberry. At this elevation, spring, summer, and autumn are compressed into three months.

○ RIGHT Frost clings to the waist-deep grasses of Leidig Meadow, awaiting the first rays of the sun. The valley's steep cliffs combine with the low angle of the sun in autumn and winter to cast long shadows and stretch frozen moments.

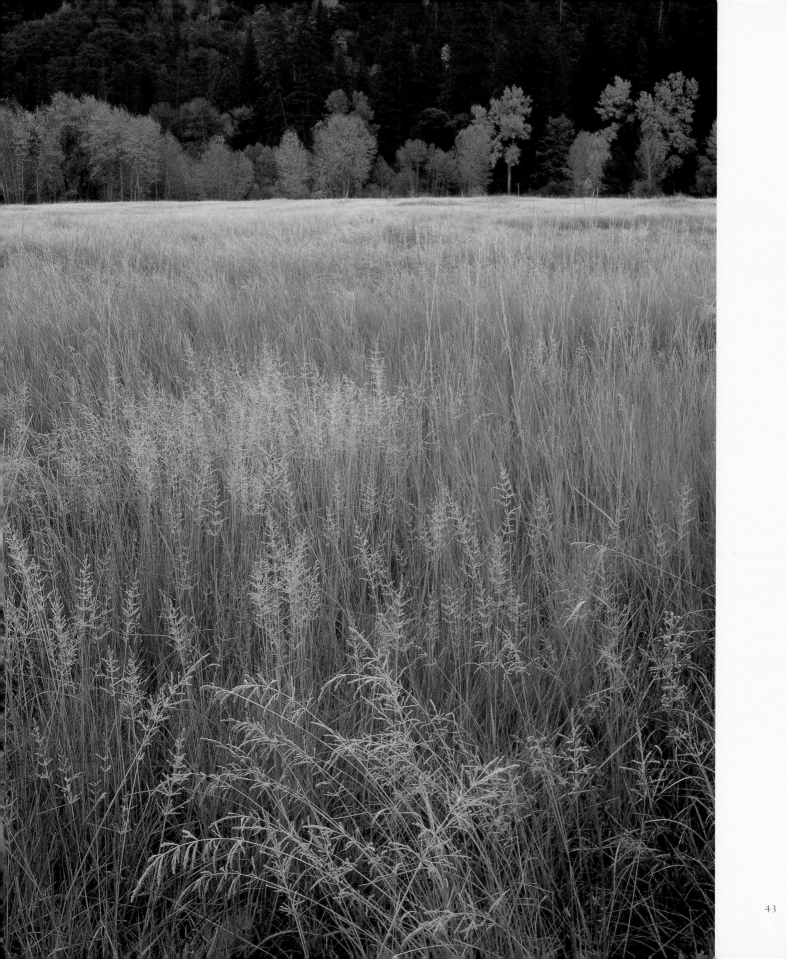

fellow mortals

While Yosemite does not have the abundant wildlife of parks like Yellowstone and Denali, it is home to some interesting creatures. Many—such as the spotted bat—are extremely rare elsewhere though common in the park. As most of the fauna is fairly uninterested in humans, Yosemite provides an outstanding opportunity to observe the behavior of a variety of animals.

The coyote *(Canis latrans)* is one of the park's most noticeable residents. Often confused with wolves, coyotes feed primarily on small rodents, though they will consume larger mammals. Their unique hunting style—as close as any canine could be to a cat— makes them fascinating to watch. They stalk their prey, ears rotating like antennae to help pinpoint the exact location of the meal, before pouncing. With arched back, straight front legs, and paws together they leap on their unsuspecting prey. Voicing an unusual collection of howls, yips, and barks, a single coyote can sound like twenty.

○ The park provides an excellent opportunity to view wildlife in a natural habitat. Though many species are accustomed to people, they should be observed from a distance. Deer and other animals startled by accidental movements have caused injury to humans.

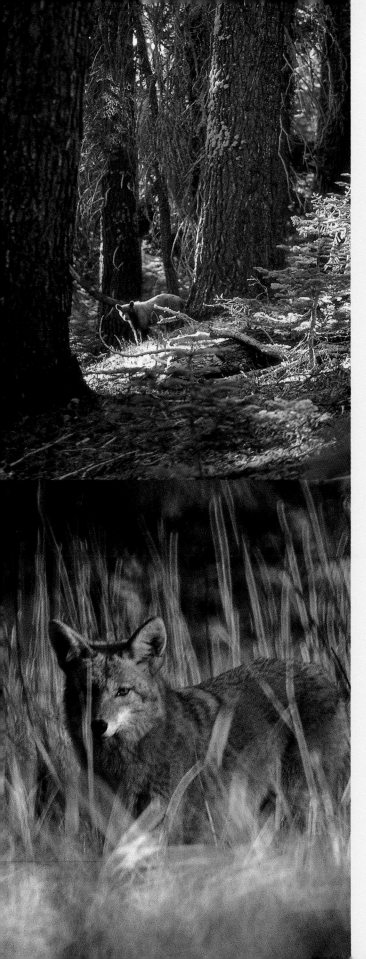

Yosemite used to be the domain of the grizzly bear, though the last one recorded in the park was killed around the turn of the century. What remains is a healthy population of black bears *(Ursus americanus),* a species whose name is a bit misleading because the color of the fur ranges from pure black to brown and even blonde. An extremely intelligent omnivore, the black bear has challenged wildlife managers with its penchant for human food. Attempts through the years to alter the bears' behavior have been replaced with a program that focuses on altering human conduct. Proper food storage is required by law in the park.

When observing the large ears of the deer in Yosemite, it is easy to understand why they are called mule deer *(Odocoileus hemionus).* Herds can be found grazing in the meadows in morning and evening, while individuals choose to recline in shady spots during the heat of the day. Though they are rarely seen, mountain lions also inhabit the park, which is not surprising because mule deer are their favorite prey.

The cliffs of Yosemite provide outstanding habitat for peregrine falcons *(Falco peregrinus anatum),* birds on the verge of extinction in the late 1970s. The park has played a significant role in the recovery of the species, the fastest bird on the planet.

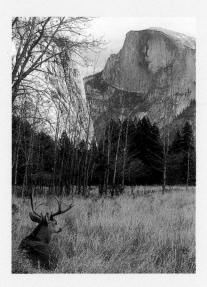

o A young black bear peers
 cautiously from the forest.
 Black bears can have fur
 ranging in color from black
 to cinnamon to blonde.

o Native Americans saw the
 coyote as the trickster, a fitting
 role for this crafty creature
 whose soulful howl is synony-
 mous with all that is wild.

o A mule deer buck reclines in
 Ahwahnee Meadow in late
 summer. Bucks grow a new
 set of antlers in spring of
 each year.

At one point in Yosemite's history, meadows were routinely sprayed with crankcase oil to reduce the mosquito population, large predators like mountain lions were exterminated so that more benevolent species such as mule deer might thrive, and bears were fed scraps from the park hotels in front of bleachers full of park guests. Fortunately, all of these practices have long since ceased, but they suggest the challenges that park managers face. Since Yosemite was the first land in the world set aside for preservation, there were no blueprints for proper management and mistakes were made.

preservation

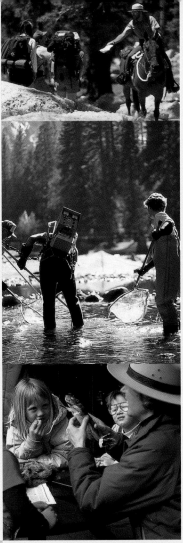

Galen Clark, the first guardian of Yosemite Valley, blasted the pile of rocks (called a terminal moraine) just west of El Capitan Meadow to lower the water table in the valley and make it easier to farm. Scientists estimate that less than 17% of the meadows that existed in the 1800s remain today, largely as a result of Clark's successful, yet misguided effort.

The National Park Service (NPS) was created with a dual responsibility: to preserve the resource unimpaired for future generations and to make it available for public enjoyment. Given Yosemite's annual visitation of nearly 4 million people, the NPS mission is ever more difficult to achieve. Yet significant progress has been made to undo the damage that occurred in earlier years, though some of those changes have required the elimination of established visitor traditions.

Visible improvements include boardwalks constructed in meadows to channel foot traffic; the restoration of eroded river-banks; bear-proof dumpsters and food lockers that encourage bears to forage for natural foods; free shuttle buses that reduce traffic congestion; and the treatment of forests and meadows with fire to restore their natural health.

Given its relatively undeveloped state, Yosemite has become, as have many parks, a bellwether for the health of the surrounding regions. Park managers not only look at the resource within park boundaries, but also seek wise management of the entire ecosystem, often forging alliances with the agencies that manage adjacent public lands.

O LEFT Elevated boardwalks protect fragile meadows by channeling foot traffic, preventing soil from compacting, and permitting natural water flow and drainage.

O RIGHT NPS resource managers routinely burn park meadows to simulate natural fires in a controlled situation. Fire is an important component of the park ecosystem that was suppressed by humans for many years.

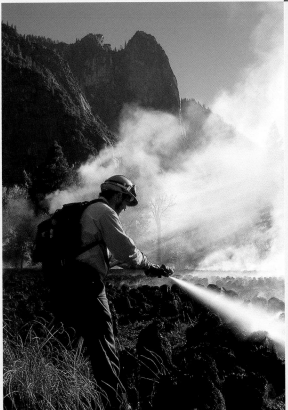

O ABOVE, TOP Multi-skilled rangers patrol Yosemite's back-country, protecting resources and helping visitors better understand their park.

O ABOVE, MIDDLE Scientists conduct a fish survey using electrically-charged backpacks that stun fish so that accurate estimates of populations can be determined and management strategies developed.

O ABOVE, BOTTOM A National Park Service naturalist shares her knowledge with a group of future park stewards. With ever-increasing pressures on natural areas, education is the key to preservation.

Years ago, while researching the human history of the park, I was looking through a guest register for one of the early hotels. In the faded and brittle pages of the volume, I encountered a variety of efforts to describe the scenery and experiences these early visitors enjoyed. Despite the passage of years, the enthusiasm that the adventurers felt, their passion for this superlative living, breathing park was undimmed. My favorite of all the flowery, detailed, exuberant notations was one that simply said, "IT."

lasting impressions

There is beauty in simplicity and in Yosemite—nothing could be simpler than sunrise, sunset, and the changing seasons.

Fifteen years after I entered the park on that hot summer day, I find my first impression has become my lasting impression, though the thoughts and emotions have expanded to match the scale of the mountains, waterfalls, flora, and fauna. We are so lucky that those many years ago, in the midst of the Civil War, individuals had the foresight to set aside such a beautiful place for us.

This is indeed a special place.

The last light of day illuminates the visor of Half Dome as seen from the rock known as the "Diving Board." Lichen and monkeyflowers eke out an existence on the granite.

○ LEFT With the valley shrouded
in fog, a higher vantage point
reveals an extraordinary scene
on the morning following a
heavy rain.

○ Under certain conditions in
February, the light of the set-
ting sun illuminates Horsetail
Fall with brilliant orange light.

○ RIGHT The Yosemite experi-
ence includes smaller, quieter
moments when the park's
immense scale is momentarily
forgotten, and the visitor is
afforded personal encounters
and opportunities for con-
templation.

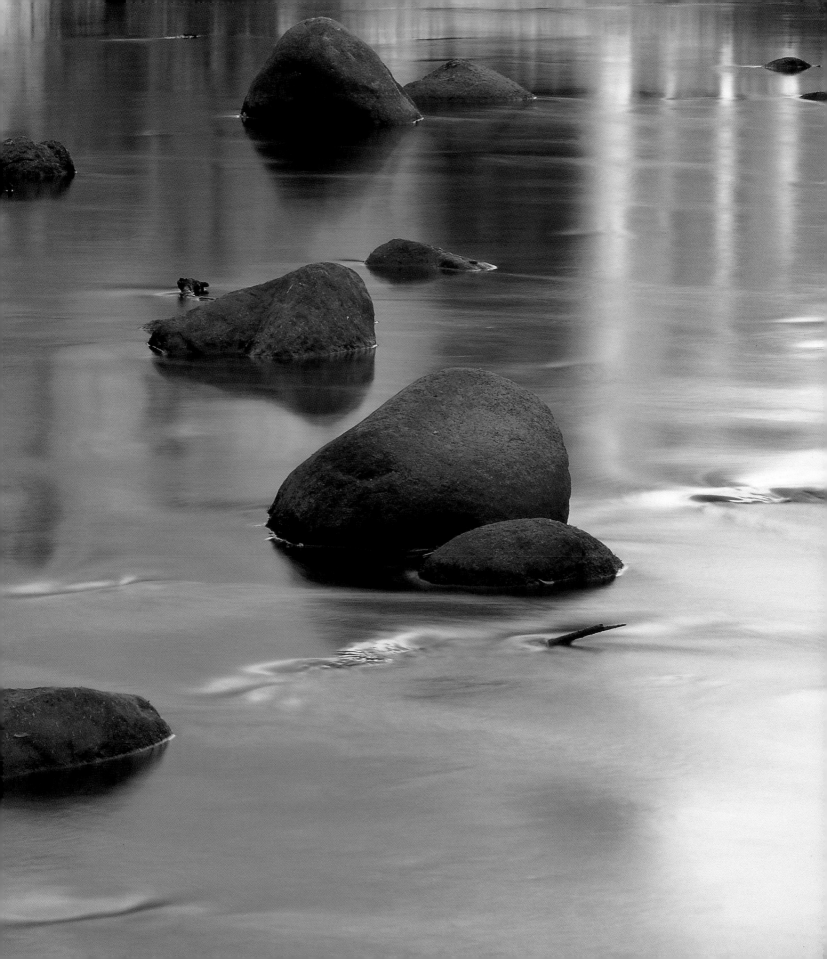

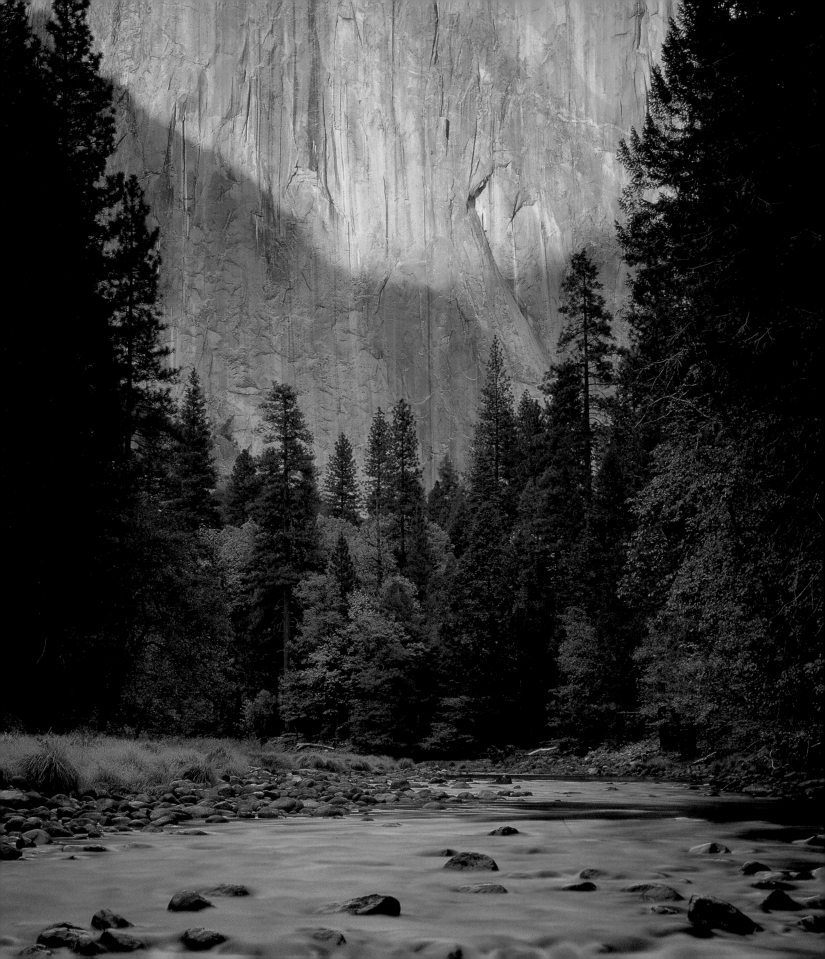

leaving eden

As one who grew up in beautiful places with plenty of woods to explore and with parents who encouraged my ramblings in the out-of-doors, I value the freedom and regenerative qualities that wilderness provides. Since moving to the west where the bulk of the land is held in public trust, I have come to understand and appreciate on a much deeper level the natural preserves that are the national parks. This 1,170-square-mile gift, Yosemite National Park, has become the perspective from which I view the rest of the world.

When I returned to the park for my "second visit" in the autumn of 1984, I was looking for food and shelter while I spent one winter in a beautiful place on which I could focus my camera lens. Fourteen years later, I realized that Yosemite had provided those basic needs, but much more in addition: food for my soul and shelter for my dreams. Only with great difficulty have I pried myself away from the park's beauty to resume my exploration of the rest of the world.

My thoughts remain deeply rooted in Yosemite's brilliant rock, muscular oaks, and energy-filled waterfalls.

I sympathize and celebrate with first-time visitors, as well as with those who visit regularly. I feel sympathy because we all must eventually depart from this Eden, and I celebrate because we have had an opportunity to experience Yosemite's magic first hand. It is my hope that the thoughts and images contained in this volume will serve to ease the parting, rekindle wondrous memories, and bridge the gap until the next visit.

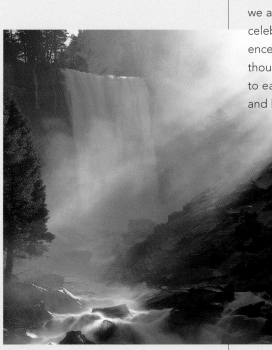

O FAR LEFT The quality of light, particularly during autumn and winter sunsets, drives the chill from even the coldest day. In those seasons, the sun's rays spread across the park's stone monuments through filters of crimson and neon, contrasting with pastel blue skies.

O LEFT Sunshine backlights the clouds of mist billowing at the base of Vernal Fall in spring.

o Wrapped in a cloak of silence, the still water of Gaylor Lake mirrors a tussle of clouds spread across the vast sky above Yosemite's Cathedral Range.